Why Photography Matters

Why Photography Matters

Jerry L. Thompson

The MIT Press
Cambridge, Massachusetts
London, England

MIT Press books may be purchased at special quantity discounts for business or sales promotional use. For information, please email special_sales@mitpress.mit.edu or write to Special Sales Department, The MIT Press, 55 Hayward Street, Cambridge, MA 02142.

This publication is made possible in part by the Fondation Jan Michalski pour l'Ecriture et la Littérature, Switzerland, and the Gladstone Gallery, New York.

This book was set in Adobe Garamond and Gotham by the MIT Press. Printed and bound in the United States of America.

Library of Congress Cataloging-in-Publication Data
Thompson, Jerry L.
Why photography matters / Jerry L. Thompson.
pages cm
Includes bibliographical references.
ISBN 978-0-262-01928-6 (hardcover : alk. paper) 1. Photography—Psychological aspects. 2. Photography—Philosophy. I. Title.
TR183.T4753 2013
770—dc23
 2012044048

10 9 8 7 6 5 4 3 2 1

Why Photography Matters

I

Like a photograph taken of a stranger, my title is a theft.

In 2008 a book appeared called *Why Photography Matters as Art as Never Before*. It is quite long, running to over 400 pages, and I have not mastered all its arguments. Nor am I convinced that some of the artists it discusses merit so much attention as photographers. But I so admire the breathless urgency of the title that I have lifted its first three words for my own, much briefer, effort. My target length is best measured not in pages, but in words.

And *brief* I intend this effort to be. *Brevity, concision, abruptness*: all qualities appropriate to a discussion of the most modern of artistic mediums. Brevity and abruptness were qualities admired by modernists as various as Andrei Bely, the Russian author who set the pace of his disjointed novel *St. Petersburg* (1913) to the ticking of a revolutionary's time bomb, and the young Walker Evans, who in 1931 published a brief essay urging postwar vision to explore "swift chance, disarray, wonder, and experiment."[1] Our modern love of speed, chance, and disarray will not only direct the progress of this essay: further on, the need to move fast will play a role in its argument as well.

Why Photography Matters: the title and the question it implies echo the urgency of another revolutionary title: N. G. Chernyshevsky's *What Is to Be Done?* Then (1863), political revolution was sweeping Europe, and would before too long threaten to spill over into Fortress America.

1. Walker Evans, "The Reappearance of Photography," *Hound and Horn* 5, no. 1(October–December 1931): 126.

Now (2012), the capitalist economies of Europe and America seem to be running out of gas: stagnation and entropy are greater threats than revolutionary upheaval. What is the urgency of a halting limp or a slowing crawl? And what has photography to do with it, that we should ask breathless questions about its importance *now*?

Well might we ask what photography has to do with it. Much of the photography we see in prestigious museums and lavish publications is decorative self-indulgence. Elegant, knowing riffs on the history of painting fill our commercial galleries and bring the highest prices at auction. Such work looks like a symptom of unraveling, a loss of vital purpose. Shouldn't photography—which began as a hyperdetailed record of our shared visible world—provide a close, critical examination of that world, the kind of jarring irritant able to rouse viewers out of a complacent, forgetful slumber, and into a wakeful regard of *what is*?

Four references and two opinions set a spare stage. Against this provisional backdrop, let me reask the title question: Why does photography matter, and why now?

Photography matters now for two interrelated reasons: One, because of how it works, not only as an artistic but also as an epistemological medium; and Two, because it presents an instructive example of what might be called *present-day understanding*. How we now—today—understand what photography is and how it works tells us something about how we understand *anything*. And it may appear that how we understand anything is not unrelated to how photography works.

II

Let me begin with Reason One, how photography works.

The camera is not *only* a tool for generating images.

Studio artists today use cameras to generate the pictorial raw materials they need in order to create works expressive of their individual talents and personal visions. For a studio artist, the camera is a source of *material*. The artist provides the *form*, shaping what the camera supplies into what the viewer sees as a work of art. The content of the artwork—what it has to say to the viewer, the experiences (emotional and intellectual) it prompts the viewer toward—this *content* comes from the artist, as it does when the work of art is a painting (or other kind of imagined image). The viewer contemplates the artist's vision. What the artist presents, as her work progresses, is a progressively deeper exploration of that vision.

The viewer who follows the work of an artist over time may come to know many facts about the world, but that viewer comes to know those facts *incidentally*, the way a reader of novels by, say, Thomas Pynchon comes to know about the trajectories of ballistic missiles or the progress of *E. coli* infections. What the serious viewer comes to know about, what he could not learn from a technical manual or guidebook, however, is something else: the vision—the intellectual and moral world—of the artist. We don't read Pynchon to learn about physics and military history; if we read him seriously we read him to learn about *his vision of contemporary reality*. We read him to come into contact with what ever since Immanuel Kant's formulation of 1791 has been called his *genius*: his

original, and unique, understanding of how the world works. According to Kant, what genius produces illuminates Nature's rules, rules the genius him/herself can embody in his/her work but not explain, rules some later intelligence may be able to analyze and make understandable to others.[2]

A studio artist works like a novelist. He or she may pay a great deal of attention to the details of everyday visible reality, but what he or she adds to those observations is the *something else*, the shaping form supplied by his or her genius. The details figure in, but they are not the main point. Walker Evans wrote in an undated note to himself that anyone who goes to Botticelli to learn about the dress and manners of the fifteenth century is a pedant and a fool. Few scholars of the future who look at Jan Groover's breakthrough still-life arrangements of kitchen utensils will spend much time considering the development of the colander in the 1970s. The main point is not a compilation of facts about the objects seen, but the genius of their combination into an original composition.

Groover (d. 2012) was, as also was the Evans (there were more than one) who wrote that epigram, not only a photographer but also an artist. But not all artists who use photography use it in the same way. To repeat: the camera is not *only* a tool for generating images.

2. Immanuel Kant, section 46, *Critique of Aesthetic Judgment.*

To find a sharp contrast to what I have been calling a *studio artist* we need look no further than the first book of photographs ever published, William Henry Fox Talbot's *The Pencil of Nature* (1844). This book consists of a number of the earliest photographs made, each pasted on a page with a brief essay/caption printed across from it. Here is an excerpt from one of the captions:

> It frequently happens . . . —and this is one of the charms of photography—that the operator himself discovers on examination, perhaps long afterwards, that he has depicted many things he had no notion of at the time. Sometimes inscriptions and dates are found upon the buildings, or printed placards most irrelevant, are discovered upon their walls: sometimes a distant dial-plate is seen, and upon it—unconsciously recorded—the hour of the day at which the view was taken.[3]

The implications of this pleasant observation extend to the extremes of recorded thought, both to its earliest beginnings and to the present *now*. For what Fox Talbot is describing is nothing less than a way of knowing the world that transcends our educations, our opinions, our intentions, hopes, and desires—in a word, our *subjectivity*. Talbot here acknowledges that the camera can show

3. William Henry Fox Talbot, "Plate XIII / Queen's College, Oxford / Entrance Gateway," *The Pencil of Nature* (London: Longman, Brown, Green and Longmans, 1844–1846).

more than its operator understood he saw when he looked at the actual scene.

For a long time photographers who wanted to be artists viewed this rich harvest of detail as a large obstacle to be overcome rather than a "charm." Many turn-of-the-century (nineteenth to twentieth) photographers turned to soft-focus lenses and worked on their negatives and prints by hand to obscure distracting detail. Others photographed carefully staged tableaux, and some pieced figures posed and photographed separately into a single composition. Now-little-known photographer-artists with names like Kuhn, Demachy, and Rejlander[4] worked with laborious printing processes aimed at making their pictures look like *real* art—like prints and paintings. Alfred Stieglitz's influential periodical *Camera Work* (1903–1917) ran an occasional column called *"Lessons from the Old Masters."* The artist-photographers of this period disdained the humble documents produced by the portraitists and survey photographers. The goal of these artists was to produce prints to exhibit in salons, not pictures to be copied as engravings and printed in illustrated newspapers like *Harper's Weekly.*

By 1920 a few photographers who thought of themselves as artists—notably Alfred Stieglitz and Edward Weston—had begun to reject this kind of art-making,

4. A sample of some of these works and detailed descriptions of the processes used to make them can be found in William Crawford, *The Keepers of the Light* (Dobbs Ferry, N.Y.: Morgan and Morgan, 1979).

embracing instead all the detail a sharp-focus lens could render. When in a 1923 note (written for the Museum of Fine Arts in Boston) curator Ananda Coomaraswamy sought to describe the artistic accomplishment of Alfred Stieglitz, he stressed that Stieglitz the artist managed to enlist every tiny observation the sharp-focus lens of his large camera took in to support the "expression of his theme." Stieglitz's great achievement was that he could control every random texture and detail as completely as a conventional artist controlled those he created with his own hand.[5]

Talbot's "rich harvest" had been tamed, enlisted to aid in the "expression of the theme." But the wildness of the lens's promiscuous harvest did not go away: it began to appeal to artists in love with "swift chance, disarray, wonder, and experiment." Some of these artists had been to France and had heard of surrealism. One of them— Henri Cartier-Bresson (b. 1908)—*was* French, and had studied painting in Paris. For these enlightened ones, the chaotic intrusion of random details captured by an indiscriminate lens was not a problem to be controlled, but a gift to be embraced. By 1924, André Breton had appropriated a line from Isidore Ducasse (known as the Comte de Lautréamont) as a surrealist standard for beauty: the chance meeting of a sewing machine and an umbrella on

5. Ananda Coomaraswamy, *Bulletin*, Museum of Fine Arts, Boston, April 1924. Quoted by Perry T. Rathbone in the foreword to Doris Bry, *Alfred Stieglitz: Photographer* (Boston: Museum of Fine Arts, 1965), 5.

a dissecting table. Cartier-Bresson, his approximate contemporary Walker Evans (b. 1903), and other talented workers of their generation began to frame and snap violent contraries yoked together by force—the force of their vision—equaling and even exceeding Breton's absurd suggestion.

If World War I could prod English poetry to change from Kipling to Eliot, its dislocations and the monstrous savagery of industrial warfare might also shake faith in the complete artistic control Coomaraswamy so admired in Stieglitz's work. Evans, Cartier-Bresson, and others embraced "swift chance, disarray, wonder, and experiment." For a brief moment, a door was left ajar—a door leading back to Fox Talbot's "charm," his welcome of the bracing surprises an image at least a little bit out of control might provide.

The door was ajar only briefly. Another concern cut across that energetic acceptance of swift chance and wonder. That concern involved *being an artist*: not even the greatest photographers have been immune to that siren's song. More about this later.

Before we progress to Reason Two why photography matters now—because it provides a case study in contemporary understanding—let me wrap up Reason One: how photography works. Talbot, and the cohort including Evans and Cartier-Bresson seven decades later, proposed (however briefly) a new kind of epistemology, a new, hitherto impossible way of learning about the world. Since the Enlightenment, studying the world had meant

proposing a model—*mathema*—and applying the model
to the world of experience, what Kant's translators called
"the manifold of sensation." The skills you had acquired,
whether they were a humanist education or a skill in alge-
bra or calculus (*mathema* gives us our word *mathemat-
ics*)—these skills were the light you shone upon raw
reality, the world. You got answers to the questions you
asked, and the answers you got to those questions were
taken to be Truth.[6]

Fox Talbot's caption suggests the possibility of
another approach (an approach, as we shall see, that was
prefigured a long, long time earlier). Though he may not
have been aware of or at all welcoming of the implica-
tion, his description of the indiscriminate power of the
lens to record detail suggests the possibility that *mathe-
sis*—reliance on the models we project to understand the
world—may not have the final say or be the final measure
of *what is*. Maybe—the quoted caption that presents his
innocent understanding of one of the "charms" of pho-
tography suggests—maybe Fox Talbot's brief essay/cap-
tion opens a door onto a new (though it in fact represents

6. Ancient Greek is (from what this amateur is able to make out) a very
dense language; words, especially key ones, usually suggest more than one
shade of meaning, often in a single usage. What I have asserted here is
almost certainly oversimplified, though I think it points in a direction that
could be called accurate. A relatively brief discussion of the complexities of
the term *mathesis* can be found in Martin Heidegger, "Modern Science,
Metaphysics, and Mathematics," in *What Is a Thing?* (Chicago: Henry
Regnery, 1967), 66–108.

a re-calling, a re-remembering of a very old) way of understanding the world.

We are already into Reason Two, but let me spend one final, brief moment on Reason One: in a hurry, *briskly*, as our modern marching orders dictate. Fox Talbot and the modernists who preferred his acceptance of the disjunctive over the late-romantic pictorialist desire to enlist every element of the picture in service of "the expression of the theme"—the gentleman scientist and the urgent modernists both suggest a new way of understanding the world. It is an amalgam of educated understanding and chance discovery. It asks that its user be intellectually prepared, but also that he/she not let that preparation predict the findings. Swift chance, disarray, wonder, and experiment will also play a role. *Mathesis*—reliance on *mathema*—will cooperate with a willingness to accept *pathema* as well. The opposite of *mathema* (a model projected to enable understanding), *pathema* is an experience passively received: acquiescence to what is seen. Our words *sympathy* and *empathy* stem from this root; *pathetic* evokes this root meaning (except when we use that word as casual jargon to mean something like *woefully inadequate*, or *pitiful*—a usage which encapsulates nicely our modern appraisal of the relative merits of aggression and reticence). When a *pathema* holds sway, the artist will no longer be Master of the Universe. He or she will be instead an attentive observer, a willing participant in, perhaps even a servant of, a system larger than that artist's individual, personal, particular needs.

I have said that the window for accepting this way of doing things was open only briefly, until the idea of *the artist* cut across it. Describing how this happens leads us into Reason Two why photography matters: how we understand things now, in present-day. The window opens only briefly because exceptional artists—today, even photographers—become famous. After that happens, their personal presence begins to attract more attention than the intellectual and ethical structures their work presents. Viewers are distracted from perhaps hard-to-follow argument by the easy-to-understand veneration of the stature fame conveys. And, all too often, the artists themselves are distracted, as well. Icarus comes to mind.

But this distraction, this falling in love with one's own brilliance and fame, is not a *necessary* attribute of photographic practice. Turning inward and focusing on self-importance are not *developments* (in the sense that as an embryo *develops*, it *must*, has no choice but to, gastrulate—because it's in the DNA, so to speak). The personal presence of the artist so often begins to distract attention from the content of the work because of how we understand things, in present-day.

III

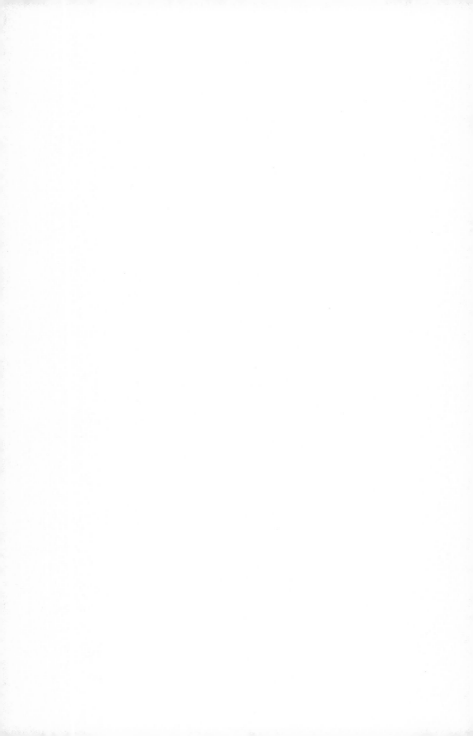

When photography is at its best, I am suggesting—that is to say, when photography is exploiting the epistemological potential that it alone among all pictorial mediums has access to—there exists a balance between the *outside* (our visible world womb/home/tomb, which, like the song of Keats's nightingale, *is*, whether we are alive to hear it or not)[7] and the *inside* (the perceiving, shaping intelligence of the photographer). When photography is at its best, these two elements cooperate as in a dialectic: one side presents a proposition, the other counters it; a new proposition emerges, one also countered in a similar fashion, and on and on as a progressively refined result appears, something neither partner in the dialectic could have produced alone.

The world presents a uniform array of undifferentiated presences, facts described by a limitless number of statements in the form of "This is a ___." There is no hierarchy, no cause and effect, no prior and latter, not even any number. Take a screen shot of any close view from Google Earth, and list every single thing you can recognize and name. This is like what the world presents.

7. The lines from John Keats, "Ode to a Nightingale" (1819) referred to are 55–60:

Now more than ever seems it rich to die,
　To cease upon the midnight with no pain,
　　While thou art pouring forth thy soul abroad
　　　In such an ecstasy!
Still wouldst thou sing, and I have ears in vain—
　To thy high requiem become a sod.

The artist has a vision, a scheme of how things fit together. Isolated and turned inward upon himself—in the Bedlam cell imagined by Jonathan Swift in Section IX of *A Tale of a Tub*, to take an extreme example—the artist's teeming brain might come up with all sorts of ungrounded, fantastical heterocosms, unchecked personal fantasies: science fiction, metaphysical systems, thought experiments, undecipherable mutterings, modest proposals for solving the world's problems. The character in Swift's cell is so self-contained he reinfunds his own excrement.

But if that teeming brain be an alert sensibility, bring it into forceful contact with the world, and—if things go right—a dialectic-like interaction can begin. The photographer tries to make a first picture of some little piece of the world—it hardly matters what. Neither does it matter where the idea that that particular collection of things might make a picture came from. But the first picture gets made, and the photographer contemplates it.

The picture shows the first, provisional agreement between the multiplicity of the world and the narrow understanding of the artist. If all the right things are in place, the artist/photographer will think about this provisional agreement, and then look at the world again, this time with a perception altered by having thought about what the first picture shows. Some random thing that appeared of no importance in the first attempt may assume a new significance now, after the photographer has seen how it takes the light, say, or how it looks next

to some other thing, now that both are isolated in the frame of a view.

If this process continues without distraction, thousands of such back-and-forths are possible: a thousand paintings is an enormous *oeuvre*, but a thousand photographic pictures can be taken (and considered thoughtfully) within the span of months, a few years, and on a tiny budget, and even by a conscientious worker who also has a day job. The active working life of a photographer can last twenty-five years, or forty years, or even more.

If all the right things are in place; *if this process continues without distraction*: these clauses from preceding paragraphs are key. A dialectical interaction of tens of thousands of steps, tens of thousands of guess-and-checks, can unfold *if these conditions are met. All the right things in place* means that the artist diligently considers the pictures as she goes, and approaches the world each time with an altered understanding of what she sees. And that the seeing practiced must not be a seeing of shapes, tonalities, and colors only, but also of the meanings and significances of the things seen.

It is possible to construct a euphonic sentence by paying attention to the sounds and cadences of the words only. But serious writers play these qualities off the *meanings* of the words, choosing words for their histories and the associations they suggest, as well as for the way they sound when read together. When Walker Evans writes: "Suddenly there is a difference between a quaint evocation of the past and an open window looking straight down a

stack of decades,"[8] the choice and sounds of the words
forcefully propel, even in part create, their sense. *Nostalgia
is different from critical regard*, the words of the sentence
mean, but the force and urgency added by the choice, the
sounds, and the rhythm of the words Evans elected are a
part of the meaning of the sentence he chose to write.

Serious photographers, as they progress, will learn
that pictures work the same way, by finding a sensible
form and an intelligible understanding together, inter-
twined and inseparable. A photographer's progress will be
more slippery and indirect than a writer's, because he is
not working with words. And also because he can't revise.
Each new try must begin—not with the blank page: that
is how studio artists begin. Each new try begins with the
untidy chaos of the world, with taking a fresh look at the
raw feast.

If all the right things are in place, a photographer will
learn from the world as much as from her own growing
skill at finding pictures. He or she will learn to prefer pic-
tures that present the world on something like its own
terms (what a fantastic thing to propose, a suggestion that
flies in the face of hundreds of years of philosophical opin-
ion: more on that soon enough), as much as those terms
can be deciphered. And some will be more patient, more
watchful, more able to decipher those terms than others—
even than those *others* who may be more talented at recog-
nizing or concocting arresting visual arrangements.

8. Evans, "The Reappearance of Photography," 126.

Those who are most talented this way face a greater challenge, and greater temptations. Theodorus (in conversation with Socrates in the Platonic dialog *Theaetetus*) suggests that it is not the very brightest who are best at philosophy. The quickest rush ahead too fast ("led about like boats without ballast").[9] The title character in *Meno* relies too much on memory. Neither is good at starting fresh and going through arguments step by step. Like quiz kids or forceful debaters, they remember too quickly how a similar earlier argument went, and hurry ahead to the next step.

Photographers with the most fertile visual imaginations may have to learn to get out of their own way, to stop short-circuiting the dialectic by jumping ahead to a conclusion too easily won. They may arrive at the highest visual perfection of their art too quickly, without the learning that can take place during repeated attempts.

Since about 1975, a high-dollar market for photographs has existed. In it, the rules of the old market for works of art apply: color sells for more than black and white; larger costs more than smaller; rarer brings a better price. So talented photographers began to work in color, make large prints, and print in limited, numbered editions. And at precisely this point in its history, photography began to change from what most workers thought it had been into something else—a *something* which could still be called photography (because of the tools and

9. Plato, *Theaetetus* 144 A–B.

materials used), but a *something* which had lost interest in the unique connection between *inside* and *outside* so charming to Talbot. The door leading back to ancient epistemology closed. A thing new (and, to many, exciting) appeared. But another thing—a thing older, and thought by many to be worn out—was, if not lost altogether, then eclipsed as many of the most talented younger workers took up the newer, more fashionable, photographic practices.

Another rule of the market is that price at auction determines importance—what we see in museums and handsomely produced catalogs today, and what important critics will write about and students of art history will study tomorrow. Today, we believe that the best artists get the highest prices. If high prices happen early in a career, the artist gets rich. As a character invented by Scott Fitzgerald famously put it, the rich are different from you and me. Yes: like the very brightest, they are less likely to engage in lengthy, laborious, uncontrollable, and humbling dialectic. Fame and its advantages can distract from such unglamorous work. The dialectic-like relationship between photographer and subject-world is fragile, difficult to sustain.

If all the right things are in place. If this process continues without distraction. The dialectic-like process I have tried to describe briefly has in fact happened: the quarter-century investigation of old Paris by Eugène Atget comes to mind. He began by making documents for artists, photographing hundreds of door knockers, stair rails,

urns, and other architectural details. As the years passed he made streetscapes and explored the parks and palaces of the *ancien régime*, in many instances returning to the same locations again and again. The pictures do not change greatly in their visual appearance, but as the years pass they become deeper, richer, more charged with meaning, and more suggestive of strong emotion. Some of this suggested emotion must certainly come from increasing age—a contribution from *inside*—but *as* certainly his continued immersion in the *outside*—in the things and places he seems to have loved—must have led him to an increased understanding of their value, their quality, and their importance.

Many early pictures (his multiple views of individual urns at Versailles, usually dated 1905–1906, for example) present their subjects with great force: figures rendered in relief on the urns enact the myths they represent, frozen forever (like the figures on Keats's urn) in mid-stride and mid-swoon, oblivious both to the scrawled graffiti of a later age and to the close attention of an impolite stranger who thrusts his viewing lens so close to their revels, peering at them repeatedly, from several points of view. The views are too carefully made, too numerous: clearly, the photographer is finding some content, and getting some pleasure, apart from his success at piling up marketable documents.

By 1920, his camera is often much farther back. Trees appear not as compilations of individual leaves, but as great dark masses encroaching upon the bright sky in

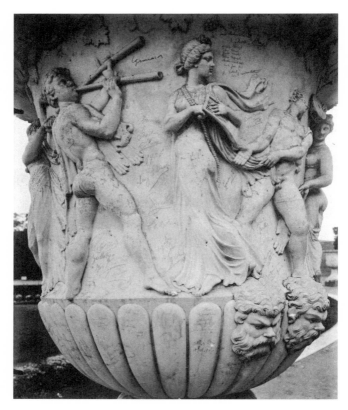

FIGURE 1.1
Jean-Eugène-Auguste Atget, *Versailles, Vase (Detail)*, 1906, albumen print, Gift of Mrs. Everett Kovler, 1963.1028. Photography © The Art Institute of Chicago. Used by permission.

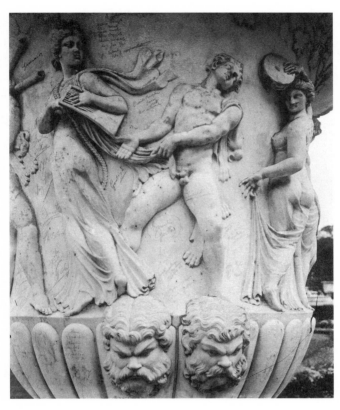

FIGURE 1.2
Jean-Eugène-Auguste Atget, *Versailles, Vase (Detail)*, 1901–1926, albumen print, Gift of Mrs. Everett Kovler, 1963.1050. Photography © The Art Institute of Chicago. Used by permission.

the upper parts of the pictures, almost like dark storm clouds. Below, a circumscribed pool—a kind of miniature inland sea, bright with reflected skylight—often contends with dark-toned grass or shadow, so that the little world in the bottom part of the pictures mirrors the tonal drama of the top. In between, architecture and sculpture occupy a middle band.

The photographer was especially drawn to the park of the Château de Saint-Cloud, a few miles west of Paris, and in particular to one of its landscaped pools. On opposite sides of a walk approaching this pool, two stone figures strike heroic poses: one, a noble male figure, pauses in mid-stride with head turned in expectation; the other, a tiny huntress, she and her hound locked forever in anticipation of approaching quarry, draws an arrow from her quiver. Other figures, progressively tinier as they recede into the distance along the approaching walk, stand with these two in arrested attitudes, fleeting gestures as fugitive as any caught by street photographers. This suspended tableau attracted Atget's notice more than once, and he photographed it from more than one angle.

It is as if the aging photographer, having studied texture and close detail for so long, is now consistently able to take in longer views with the same degree of mastery. And this mastery lies primarily not in control, though by the 1920s his understanding of how things and light would appear in a picture is very great. These things are by now second nature to him; it is in his *receptivity*, and

FIGURE 1.3
Eugène Atget, *Le parc de Saint-Cloud*, 1916–1919. © Bibliothèque
nationale de France. Used by permission.

not in his willful ability to wrest an effective picture from a complicated or intractable scene, that his mastery lies. His great experience of looking at the same things for so long has combined in a deep way with the age he has attained, age resulting from a long life whose main energies were spent in this very looking. The contemplation of Old Paris has made him old in Paris, and his understandings of both these states of affairs—the rich, complex, splendid city, and what Wordsworth called *the unimaginable touch of time*—flow together, blending their multiple streams of force into the power of these late pictures.

Garry Winogrand comes to mind as well. If, as I have suggested, great visual talent can be a challenge for a photographer who would learn from his subject, no photographer of recent times was more challenged in this way than Winogrand, whose ability to recognize a provocative arrangement of shapes in a frame was matched in degree only by the brevity of the time it took him to do so. He walked the streets in his daily rounds accompanied not only by this awesome talent, but also by his personal entourage of manic demons. He had a lot going on *inside*, but no one who looks thoughtfully at a large number of the pictures he made on city streets will fail to recognize the deep human content he was able to see *outside*, on those streets. As a lecturer, he avoided that aspect of his work altogether, often saying he photographed in order to see what things look like in photographs. He pretended to be merely an expert technician at work on subject matter of use to him.

Winograd (d. 1984) took nearly a million pictures, including thousands he never saw (his photographic estate included hundreds of rolls of exposed but undeveloped 35-millimeter film). Many of these pictures look like stunts, successful attempts to freeze a number of moving and shape-changing figures at the vanishingly brief instant when all these positions and shapes added up to a coherent visual pattern within his viewfinder's frame. Like the skill of circus jugglers who continue to add more balls, more rings, more daggers, more flaming batons, an increasing level of virtuosity eventually is of interest in itself. It is exhilarating to see someone do what no one else can do, however pointless the stunt.

But very many others of his pictures take this skill only as a means to look at something truly worth seeing, something only someone who had learned from the street (or at least from looking at people) might bother to try to see. With Winograd, the actual time he accumulated over years of looking at the same or similar subjects may matter less than the uncanny degree of close attention he paid to what he saw, even the first time he saw it. As early as 1960 Winograd was regularly photographing collections of people whose attitudes and connections to each other prompt thinking that goes way beyond admiration of his visual skills and hair-trigger timing.

Winograd spent a lot of time in Central Park, and he often visited the zoo there, photographing not only the animals but also the people watching them. One of these pictures (from the early 1960s) has a joke on its

surface. It shows a random assortment of people lined up against the viewing rail surrounding the seal pool, but none of them is paying much attention to the seals. The picture is a vertical one (less common than horizontals, in Winogrand's work), and the bottom part of the frame shows a group of seals swimming energetically toward the people arranged along the rail. The animals are watching the people: that's the joke. My account so far of this picture might fit any of the scores of pictures published over the years on the last page of each issue of *Life* magazine. It's funny, and you get the joke at first glance.

But this picture offers an impressive level of detail, and the detail is spread all around the frame of the picture. Winogrand's framing is careful to acknowledge the importance of both groups: neither group is centered left to right at the expense of the other: the humans are a little off-center to the viewer's right in order to avoid forcing the pod of seals uncomfortably far to the left.

If, after getting the joke, a viewer lingers to focus on the upper group—the four anonymous visitors lined up at the rail—that viewer will find much to look at and think about. The clarity of description invites the viewer to study what might be attracting the attention of the seals.

The dress of these four suggests a middle position in society, neither put-upon outcasts nor upper-crust: these are ordinary folks at the zoo. The central couple seems to offer the most, at—not first, but *second* glance (first glance disclosed the joke). A girl endures the romantic attentions of her companion, but her thoughts seem elsewhere. She

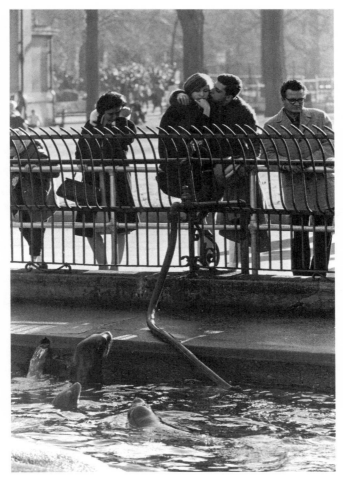

FIGURE 1.4
Garry Winogrand, *Central Park Zoo, New York City*, ca. 1963. © The
Estate of Garry Winogrand, courtesy Fraenkel Gallery, San Francisco.
Used by permission.

looks away, perhaps in distraction, perhaps in the general direction of the pool. Her cute pout, her carefully massed hair and makeup—one visible thumbnail flashes white out of the shadowed mass of her curled-up body—suggest that a Narcissus-like glance down at her own reflection would not be out of order. She is physically part of a circumstantial couple, but withdrawn, her body curled up like a fetus (or a brooding figure by Michelangelo), her facial expression distracted and distant.

Her escort stands in tense solicitousness, stiffly against her curled mass. His face registers concern, as if he wanted more from her than he was getting—a return of his kiss at least; his smooth grooming and pretty-boy face suggest he thinks he has reason to expect more. It would not be completely out of character for him to interrupt his amorous labors for a glance down at the pool. These two attractive young people are in close conjunction, but disconnected, a tight mass of low-key romantic tension in the picture's middle.

A sort of subplot, or overtone, flanks the couple on either side, each side character presenting an imperfect, incomplete reflection of some aspects of the central pair. The man is not a likely candidate for membership in a romantic couple; his heavy glasses, knee-length coat, and buttoned-up collar might be more stylish today than in 1960, when the nerd look was not thought to be cool. He stands awkwardly at the rail, and his face suggests an attitude not easily described by one or two words. He looks a little puzzled, a bit uncomfortable, possibly as a result of

his own inner thoughts as much as of what he sees with his corrected eyes. In a well-known picture by Henri Cartier-Bresson of the last British governor-general taken at the exact instant of Indian independence, Lord Mount-batten's open mouth and averted gaze read as an aberration, a change from a customary attitude of authority. This man's puzzled discomfiture reads as what Hawthorne termed *the settled temper of a life.*

The other flanking figure is a woman alone. She is weeping, and drying her face with the heel of her hand in a rough, indelicate gesture suggesting distraction, even desperation. One leg is bent at the knee, and one hand grasps the rail as if for support. She has come out into a place of public amusement and stands at the viewing rail, weeping out some private sorrow.

Winogrand could be said (as the young Stendhal aspired) to be "a student of the human heart." He is a psychologist, but one who (like Shakespeare and Molière, Stendhal's models) works from observation and instinct rather than theory and analysis. His photograph presents a three-ring circus, but with precise observation and exquisite timing that take it far beyond the "human interest" pictures of the picture magazines, and equally far beyond the stunt of organizing for organization's sake: the picture presents three variations on what writers since Balzac have called the human comedy. *Normal,* in this picture, is midlevel dysfunction, some missing of the boat, some falling off from the ideal standard. The dys-, the missing, the falling off are not exaggerated or hyped:

they are just *there*, as they are in the lives of most of the people we know. The picture shows neither freakishness nor operatic drama. It shows humanity, *comic* in the classic sense.[10]

The seals who swim up to watch not only make the joke, but also act as foils to play against this civilized human world, like the fairy in *A Midsummer Night's Dream* who has the great line: What fools these mortals be. They appear as natural intelligences who get it more nearly right than anyone else in the picture. Animals behaving as intelligently as (more intelligently than?) humans: that observation might prompt a whole separate line of thinking.

Organization of the frame, the visual equivalent of rhetoric, is here used to set the stage. The astonishing level of skill needed to see and arrest so many telling things at the same time almost hides its hand: it prepares the scene rather than becoming the main act. The scene prepared is not a hard surface, impervious to penetration, designed to invite admiration but discourage inquiry. The artist acts decisively to create a structure that invites the viewer in, and leaves room for thinking. The muscular frame, the skillful organization, the perfect timing are all preliminary, serving only to launch the inquiry, to propel thinking above the actual things shown and

10. That is, in the sense that the characters shown are superior to us neither in station nor in action. See Northrop Frye, *Anatomy of Criticism* (Princeton: Princeton University Press, 1957), or one of his main sources, Aristotle, *Poetics*.

toward the insights prompted by a contemplation of these things, in the state we find them in at the instant we are shown them.

There are of course many other examples from the past of what I am calling a dialectic-like interaction between photographer and subject. I think it is happening still: this process, this way of working, has no more been somehow "used up" than the practice of representational drawing and painting was "used up" by the end of the nineteenth century.

Consider a relatively recent picture, one taken by Marcia Due (b. 1947) in the late 1990s. It is a landscape detail made in Dutchess County, New York. When she made this picture, Due had been photographing agricultural landscapes in this region regularly for more than twenty years. This view does not look much like the pictures she took at the outset, which tended to be from farther off and to show some more easily nameable aspect of agriculture's use of land. At first glance this picture shows a mass of detail gathered at the center, which becomes more airy and lighter in tone nearer its margins.

The actual things shown are not readily nameable, and the transition from *thing* (rising above the water's surface) to *reflection* (image on the water's surface) is not immediately apparent: the seeing of this view is a little playful, challenging the viewer (in a gentle way) to look more closely. Also challenging—engaging, actually—is the overall form of the picture, which suggests exuberant expansion, as if it were a picture of a bouquet rather than

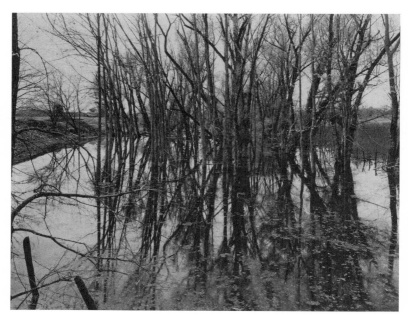

FIGURE 1.5
Marcia Due, *untitled* (agricultural landscape, Dutchess County,
New York), late 1990s. © Marcia L. Due. Used by permission.

a farm scene. This lively, unexpected form (like all the detail visible in the Winogrand picture) attracts the viewer's attention, and encourages him to look.

As he looks, the viewer will find more and more things that happen to sit in happy relationship to one another: the sticks in the left foreground, for example, attract our notice, but the visual emphasis they create is answered (or "balanced") by the farther off (and much smaller) sticks or poles on the right. The difference in their sizes emphasizes the physical dimension of the deep space this view comprehends.

But what else does the view comprehend, other than deep space, subtle visual organization, and a pleasing, unexpected overall form? Looking at the scene (which this picture articulates so nicely) will lead a thoughtful and patient viewer to wonder what this little body of water is, how it came to be. The general condition and topography of the visible landscape suggests the land has been *worked*: a pile of loose earth on the left side of the picture supports this hypothesis. Is the tiny (but in razor-sharp focus) vehicle just beyond that pile the earth-moving machinery responsible? A closer look shows it to be a school bus.

Is a school bus in a farm field like an umbrella or a sewing machine on a dissecting table? In fact, school buses are not so unusual to find in upstate New York farm fields. After their useful lives on the road they are still serviceable as enclosed shelters. They are cheap to acquire, require no time and effort to construct, and don't have to be trucked to the location where they are

needed. On a farm, incongruent appearance matters less than utility, cheapness, and ease of installation.

This stretch of land was certainly cleared, and probably plowed and harvested, its surface and water-shedding properties altered by its farm use. The occasional dip in the land's surface will collect water, just as a mature tree that has somehow survived in the middle of a field will alter that field's plowing and planting pattern (subject of several earlier pictures by Due).

The fact that the two poles in the left foreground are actually *fence* poles (the thin fence wire is in focus as clearly as the school bus in the far background) adds another layer. The fence suggests the presence of livestock: the land may have been grazed, as well, and the pond may have been excavated as a watering tank. Or the farmer may have enlisted an accidental depression for this use. The size of the saplings suggests how long such departures from ideal geometry, such improvisations, will survive, on a working farm, without willful remediation. Aesthetics—the creation and appreciation of beauty—is an interesting, provisional component of the garden-world of this picture, which is not the formal garden-world of Le Nôtre.[11] Here, no preconceived rules of design (or geometry) come into play in either subject or picture.

11. André Le Nôtre (1613–1700), the landscape architect and gardener responsible for the gardens at Louis XIV's Versailles (and also for the park at Château de Saint-Cloud).

These observations appear gradually to the viewer who continues to look at the picture and think about what she is seeing. The picture presents no strident, over-riding message, no complaint or recommendation about agriculture, land conservation, or anything else. Its deli-cate form holds many things up—in balance, so to speak—for the viewer to consider for as long as the pic-ture holds her interest, and as far as her understanding, general awareness, and associative ability can take her. Some viewers like to be told right away what to think, so they can turn the page and get on. Others like to linger. What this picture has to offer appeals to the latter group.

This picture would not likely have been the first pic-ture the photographer made of this general subject. One of the causes leading to its making was sustained, thoughtful looking not only at the subject itself, the farm landscape of the eastern part of the mid-Hudson Valley, but also at the pictures she was getting from that subject. Through seeing how things look in pictures, a photogra-pher comes to understand not only *how a thing means*, when its image becomes part of a picture, but also *what* that thing means, in the context of the world in which it is shown.

Photographers who care only about information might be called journalistic; their pictures need captions, and the captions often do the same work as the pictures, though with less visual impact, the way museum labels for "difficult" artworks do. Photographers who care only about how the picture looks might be called pictorialist;

their pictures need captions no more than a symphony needs a "program," or story the music can be thought to tell (a storm, the Resurrection, etc.). The richest, most fully realized photography is made by those who work somewhere in the middle.

Working in the middle involves studying the subject matter (as I have suggested Atget studied Paris), but also studying, or at least respecting and valuing, the way things look in photographs. One of the things displayed by the landscape detail we are considering—one of the things it holds up in balance, for the viewer to consider— is a sophisticated understanding of how photographs work. Let me imagine, for a moment, some of the considerations that *might* have come into play as a sophisticated photographer came to make this picture. (*Might*: I am here only speculating on possible pathways, processes which, even if they occurred, were almost certainly not fully or even partially present in the consciousness of the actual photographer who took the picture.)

The recognition that a pond or pool might provide a suitable occasion for a picture could come from a number of sources. About the time this picture was made, a picture of a moonlit pool by Edward Steichen brought some then-incredible (but long since surpassed) record price for a photograph at auction: it was in the news. T. H. O'Sullivan (a nineteenth-century survey photographer) made a striking, memorable (and famous) stark picture of a lake in the desert, a picture known to most photographers who worked with large cameras about the time this

picture was made. Atget often included bodies of water in his pictures, and Walker Evans, after circling a house that interested him in 1973, photographing it repeatedly with a hand-held camera, returned to his car and announced in mock triumph to his assistant: "Well, I guess I got *that* one, including the obvious puddle shot."

So, for a sophisticated photographer surveying a field of interest in the late 1990s, a body of water might have rung a bell of possibility. And, in approaching this body of water, a photographer *might* find that ideas about picture structure would come into play: *shoot it head-on* might be a first thought for some photographers.

But shooting it head-on suggests the obvious significance of some discrete thing to be shown, something that would be self-evident in a clear, straightforward rendering (as in an evidence photograph taken at a crime scene). What if the *subject* is not a single, obviously significant thing but rather (as in the picture we are considering) a nexus of delicate interrelationships and connections? Then maybe a more playful, less straightforward approach might yield richer results. *Tell the truth but tell it slant*, wrote Emily Dickinson. The astronomer husband of Emily's brother's mistress would have known that looking directly at a faint object is not the best way to see it, because the center of the retina is not the part most sensitive to light: a better technique is called *averted vision*, looking a little off to the side.

So a visual strategy involving indirection might come into play. Exaggerated perspective and the conflation of

things near and far might appear as fruitful possibilities, as might an openness to the slight difficulty of distinguishing object from reflection in black-and-white two-dimensional pictures. The former technique appears in photographs by Atget; both appear again and again in photographs by Lee Friedlander.

All these and many more possible pictorial strategies might present themselves to a sophisticated photographer as she carried her 40-pound camera through the fields where that pond had formed. But running beneath all this—and *coming before it*, in the photographer's attention—would be the physical experience of walking in that particular field, and of the specific light and weather; and also the memory and experience of walking this and similar fields many, many times before. Pictorial considerations, though likely in play, would be down deep, submerged beneath the immediate physical demands of the moment. Also down deep—but still available on some level of memory or association—would be the memory and experience of developing, printing, washing, flattening, spotting, filing—and *looking again and again* at—the hundreds of pictures of similar subjects she made during the preceding decades.

Our popular art criticism extols the *original*; our art markets place a higher price on the *unique*. At the moment this picture was made, the photographer was far, far into a long, continuous conversation with her subject, and also in touch with the memories and experiences of her own pictures, and of pictures made by others.

Drawing on these rich substrates, she would—if it was a good day—see possibilities leading to a successful picture no one else would likely have recognized. Working at this pitch involves drawing on everything she might know about how a subject of interest distills itself into a photograph that is neither *only a statement of simple fact* nor *only a well-formed picture*. The picture she got is both, with the qualification that the fact involved is not simple.

An attentive reader will have noticed that I have long ago abandoned my promise of abrupt brevity. But I have done so in the interest of truth, in the interest of fidelity to things as they are. And truth requires that I make one more point about the landscape detail we have been considering. In imagining the thinking that *might* have gone into the making of this picture I named a number of photographers whose examples may have suggested possible pictorial strategies to use in dealing with the complex subject matter this picture addresses. In fact my use of these names is a sort of shorthand strategy, like choosing a familiar brand when shopping in a hurry rather than taking the time to read every word of every label of every product of the kind offered for sale.

In fact it is *not* the personal example of any one famous photographer (*a strong brand*, as a marketer might say) which comes into play when a photographer is working at this level, at what I am arguing is her best. It is not the personal achievement of a single Great but rather the *analytical principles*, both intellectual and pictorial, contributed by many Greats to photographic discourse that

come into play for a serious photographer, one at least as aware and respectful of his subject as he is aware of his own performance as an artist.

Principles and personalities: what's the difference? the reader may be thinking. Aren't you just saying that the idea comes at least in part from other art? Brevity be damned. We may need another example, a contrasting one, to demonstrate the difference between the dancer and the dance.

In discussing the landscape detail I identified strategies and linked them to the names of well-known photographers. Due's picture does not quote, nor drop a hint about an obvious model. No single influence stands out above all others. The making of the picture enlists a number of strategies we might think of as having been recognized and melded into a sort of logic of picture-making. The photographer has *assimilated* these principles, and draws on that assimilated logic in making a work she needs to make *for other reasons*: not for reasons having to do with establishing her abilities and position as an artist, but for reasons having to do with understanding her subject.

Logic can be understood as different from style. Logic is a priori: fundamental and unchanging, having genuine being before (*prior* to) strategies having to do with making this picture arise. Style is contingent: shifting, dependent upon what might be useful right now, upon changing notions of taste, *of the moment*. The most substantial photographers draw upon (and assimilate) logic into their pictures when they are doing their most

solid work, the work that connects most effectively with an urgent subject. Lesser photographers, and great photographers when they are not at their best, or not in front of a subject that engages them deeply, play with style.

Consider one photograph by Robert Frank, whose body of work is firmly established as one of the great achievements of mid-twentieth-century photography. In his book *The Americans* (1958), Frank published a picture of a covered car parked in front of a bungalow framed by two palm trees (*Covered Car—Long Beach, California*, the 33rd plate in the 1969 expanded edition of that work). The picture makes its own statement, is about its own place and time. But in doing so, it plays off—it makes an obvious reference to—a specific photograph by another photographer. Frank's picture, taken in 1955, can be seen as an update of Walker Evans's photograph usually titled *Westchester, New York, Farmhouse, 1931*, published in *his* book *American Photographs* (1938) as Plate II, 8.

Frank's picture (like Evans's) shows a car, a house in a distinctive architectural style, and trees. What is at work in this picture is not some logic of combination taken not only from the Evans picture, but also from other, similar pictures. In fact the perspective of Frank's picture and the framing used to relate its principal elements to each other are quite different from what we see in Evans's view. Evans's picture (of which he printed more than one version, each version seen or cropped slightly differently) is taken from so great a distance that its perspective approaches the orthogonal perspective of architectural

This space was intended to present a photograph by Robert Frank showing a covered car parked in front of a southern California bungalow flanked by palm trees (*Covered Car—Long Beach, California*, the 33rd plate in the 1969 edition of *The Americans*).

A message delivered to the author by a representative of Mr. Frank reads as follows:

"After reviewing your request, I regret to inform you that Mr. Frank did not grant permission to use his work in your upcoming publication. It is the artist's preference that his works not be used as comparative images."

FIGURE 1.6

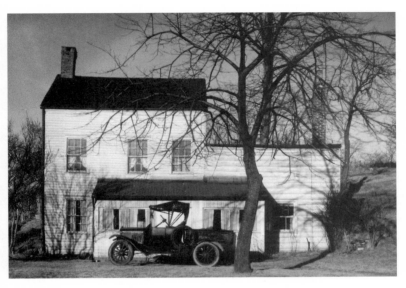

FIGURE 1.7
Walker Evans, *Westchester, New York, Farmhouse, 1931* (variant).
From a trimmed, mounted print signed by Evans in 1971. © Walker
Evans Archive, Metropolitan Museum of Art, New York City. Used
by permission.

elevations: lines parallel in the architect's plans (had there been any) are parallel in Evans's picture of the house. Frank's picture is snapped (though with great sureness) with a normal lens, as if from where he happened to be standing. The camera is pointed up slightly, to include more of the palm trees, so the lines defining the corners of the house façade (and the trunks of the palm trees) are not parallel, but convergent. The more recent picture does not distill the earlier picture's achievement into principles, and then apply those principles; rather, it references the earlier achievement itself as a personal event that happened once, at an earlier time. It *references this achievement*—and this is to be contrasted with *assimilates principles discernible in this and other sources*—as something Frank uses, perhaps needs. A good part of the picture's energy derives from Robert "talking" to Walker, echoing and updating the earlier picture, and raising the ante of the conversation by using a more fluid, flashier frame.

Like all serious works of art, this picture offers more than one aspect, and the attitude toward the earlier work (and worker) it suggests is not a single or simple one.[12] Respect may well be one component part of that attitude. But something else is at work as well: at least part of the picture's energy goes into a kind of one-upmanship. The covered car is slick, smooth; the California house is slick,

12. For a fuller discussion of the connection between these two artists, see Tod Papageorge, *Walker Evans and Robert Frank: An Essay on Influence*, first published 1981 and reprinted in *Core Curriculum* (New York: Aperture Foundation, 2011).

smooth; the frame is gray, smooth; palm trees (warm cli-
mate, lots of sunshine, easy living) preside. Not like the
clunky black car, all angles and stick-like lines under a
stick-like wintry tree, hard black lines contrasting with
the white of the foursquare frame house. Parson Weems's
carriage in front of his Protestant parsonage. We see the
cool fifties blowing off the earnest thirties. As one later
critic would put it, it is one *moral universe* contemplating
another: history's page has turned, man.

Frank addresses Evans the way a second jazz musi-
cian might give a clever answer to a first who has intro-
duced an intricate riff. As Harold Bloom[13] might have
described it, Frank is a Strong Poet contending with a
precursor Strong Poet. Such contention is personal: it
takes us away from the realm of *logic*, the solid a priori
upon which dialectic can build, and into the realm of *per-
sonality*, celebrity, fame: a house of cards built upon the
sand.[14] In this realm—to repeat, only one of the realms a
picture like this takes us to—it is performance that mat-
ters, and not truth.

13. Author of *The Anxiety of Influence* (Oxford: Oxford University Press,
1973), among many other works touching on the subject of poetic
influence.

14. Though this essay does not deal with the notion, it is important to
understand that an artist who is a genius may build a house of cards which
will not only stand, but also affect the way other structures are built in the
future. It is also important to understand, however, that there are many
more famous personalities than there are geniuses.

IV

Though we today can hardly get through a conversation without using it, the word *personality*, indicating a remarkable or at least noteworthy degree of personal presence, represents a relatively recent addition to English usage. Emerson and Ruskin in the mid-nineteenth century were among the earliest writers to use the word in this sense. Some words—*substance*, for example, or *emotion*—may carry meanings we can't instantly give with precision, but they are made from components which are quite concrete and easy to visualize: *sub-stance* refers to something that stands under something else; *e-motion* describes a movement outward. *Personality* is based on *person*, a very old word, but a word whose foundation is hard to discover. It is used very early to describe dramatic presences—*personae*—as well as actual human ones, and its earliest formation may derive from the Latin *per sonare*, meaning *to sound through*.

With words like *substance* and *emotion*, we look for the specific meaning and find a physical arrangement or an action clearly described. With *personality*, we are sure we know exactly what its specific meaning is because we use it so much, but when we look for the physical arrangement or action at its root, we find it is not a thing at all but, rather, a medium for something else. The picture we come up with is not of some concrete source but, rather, of a mask or a megaphone. In this model, what is it that is sounding behind the mask, through the megaphone?

When we today think about photography as an artistic medium, most of us will begin by thinking about the best-known artists who practice it: the personalities we single out as *great artists*. If asked what photography is today, someone who keeps up with things in general and takes an interest in art would likely respond by naming a few practitioners whose work is of interest, or seems important. This person might mention Richard Prince, Cindy Sherman, Thomas Demand, or some other artist who has been written about recently, someone whose pictures are exhibited frequently in prominent venues and sell for high prices. Fifteen years ago that same person might have mentioned Richard Avedon, Robert Mapplethorpe, or one of the generation of then-young German photographers known as the Düsseldorf School. Forty or fifty years ago the first name mentioned might have been that of Ansel Adams, and ninety years ago the name would have been Alfred Stieglitz or Edward Steichen. Longer ago than that, the question would likely not have been answered by names because the field had not yet produced any celebrity photographers, any outsized *personalities*. Photography was not yet an arena for celebrity practitioners. As late as 1900 the New York Camera Club entertained a motion to convert itself into a bicycle club.

For reasons too complex and far-reaching to attempt to discuss here, we today tend to define any field of interest in terms of its dominant personalities. Perhaps Walter Lippmann (*Public Opinion*, 1922) or Elias Canetti (*Crowds and Power*, 1960) might suggest some possible

reasons for the modern reliance on personality. But certainly this tendency in present-day thinking acts as a handy short cut, a way of cutting through the enormous complexity (both logistical and intellectual) all of us face every day. When we look at a puzzling work of art, we may try to untangle the thinking that led its maker to imagine that artwork as a thing possible to make. More likely, we will focus on how the work looks—its style—and think about where that style came from. We will think about influence, and we will end up talking about Walker and Robert.

When we make things personal, another element is added to the dialectic-like process I tried to describe earlier. Then, I proposed that a serious photographer might establish a kind of dialectic with a subject—old Paris for Atget, upstate New York farmland for Due, city streets for Winogrand. Over time, I suggested (or in the case of Winogrand, perhaps more quickly, as much as a result of extreme concentration as of repeated observation), dialectic advances to the extent that the photographer sees things in the chosen subject matter no one else would likely see.

In my initial description I specified two qualifications: *if all the right things are in place*, and *if this process continues without distraction.* The notion of celebrity photographers (or "strong poets," to use Bloom's term) adds another kind of dialog that cuts across the one in the model initially suggested. Robert "talking" with (or, again in Bloom's terminology, "contending" with) Walker is different from Atget

"talking" to old Paris. The contention of strong personalities is different from an investigator (and perhaps one with a modest personality at that) progressively interrogating, and getting to know, a subject.

This state of affairs raises a question: is this second dialectic-like conversation—the "conversation" among Strong Artists—a distraction only, or does it add something of value to the enterprise—perhaps a *something* necessary in our time (a time in which *personality* and *celebrity* matter so) for fully realized work? Or, put another way, is our present-day shorthand focus on the personality of artists a legitimate development (recall what *development* implies), an "authentic" aspect of present-day reality, or is it a short cut that sacrifices in fullness and complexity more than it gains in speed and abruptness?

It may be the answer lies somewhere between the two extremes both forms of the question suggest; if it does, then maybe the question should be asked in the broadest way: must *swift chance, disarray, wonder, and experiment* necessarily dominate any attempt to understand and live life in the present-day world, or are these things merely choices from among many possible enthusiasms still available today (even if some of these possibilities are not easy to see, and not likely to appeal to many)?

V

This last question is a broad one, and trying to answer it directly will tempt us to generalizations as dangerous as they are sweeping—even though generalizations can sound or read reassuringly abrupt and forceful: to the modernist taste. More about that soon enough; for now, as a way of beginning to consider this Big Question, consider a very small thing: the mathematical procedure for calculating the square root of a number. Fifty years ago, every student learned to do the long version of this calculation. No one today performs that algorithm; inexpensive calculators and now universally available computers have taken over that function. No one any more does it step by step. Few even remember how.

Fewer still remember how a square root came to have that name, or what a *root* or a *square* was before we all began to speak glibly about "square roots," a mathematical short cut useful in solving problems with practical applications: what will be the dimensions of a quarter-acre-square building lot? We use the concept without thinking about where it came from.

Our understanding of words like *truth* and *beauty* is similar. We use them and assume everybody who hears us knows what we mean by them. And everybody does—*in a general way.* But it is precisely the *generality* of this understanding that limits—one might say *blocks*—our discourse from really understanding anything. The words we depend on have become something like the Black Boxes technologists speak of. A Black Box is a discrete assembly, a device that does something you need done:

problem goes in one side and *solution* comes out the other. You don't know (or care) how it works, so long as it does the job, solves the problem at hand. (That it may also be doing other things, too, is not something we usually concern ourselves with at the time the Black Box comes into wide use.) An external hard drive is one kind of Black Box, an electronic one; a psychotropic drug is another. A dumpster is a third.

Present-day life depends on a lot of Black Boxes. If Socrates wanted to go from Athens to Piraeus, he walked, step by step, on bare feet, we are told; not even the technology of shoe-making was taken for granted. Today we would enlist a couple of tons of steel, plastic, and electronics, a construction so complex no one alive can explain how every single component part works, let alone why.

According to the testimony of Plato, whenever anyone in conversation mentioned words like *knowledge* or *virtue*, Socrates was likely to turn the conversation to figuring out exactly what those words actually mean. He couldn't resist unpacking the Black Boxes, examining accepted notions to see what they actually meant. The phrase *go into it a little further* turns up frequently. Sometimes—often—his attempts are destructive: participants in the conversations (or *dialogs*, as they are usually called) end by having to admit they really can't say exactly what the disputed word means. But the destruction is never final, or nihilistic: the questioning serves to prompt deeper thinking and further discussion. Until the end of the *Phaedo*—the dialog that ends with the death of Socrates—there is always another

day, another group of talkers, another word (or the same word taken up again) to examine.

The goal of philosophy is not to compile lists of famous philosophers or of positions and arguments to learn like strategies in chess or debate. Its goal is to keep thinking alive, to ensure that nothing—or as little as possible, at least—is accepted without good reason, without having been built up logically from unshakeable (or at least the deepest possible) foundations.[15]

Present-day discourse does not often have time for this nitpicking. Aphoristic sound bites allow us to get through a subject of interest quickly, if superficially, and referring to the authority of a famous (or, if you prefer, *successfully branded*) personality can help position an aphorism as *oracular*. So far in this essay, I have been considering how photographers approach the world that is their subject—(1) via the patient, observant, dialectic-like process I have tried to describe, or (2) by an abbreviated technique relying on the "personal" vision of a studio artist, and also perhaps relying on the kind of direct, challenging response a later worker presents in his work to a famous precursor. The former ("dialectic-like") procedure is linked to what I have just called "the goal of philosophy." The latter ("abbreviated") procedure, I have been suggesting, is terribly attractive to the *pace* and *temper* of present-day life.

15. Of the many learned opinions possible to cite in support of this sweeping assertion, let me cite only one: Eva Brann, "Introduction to the *Phaedo*," in *The Music of the Republic* (Philadelphia: Paul Dry Books, 2004), 3–35.

This distinction between former and latter applies not to the practice of photography only. Consider the distinction from another angle: let us shift the ground from the *practice* of photography to a discussion of how we *understand* photography. (At this point, the attentive reader will note, we have finally arrived, much later than promised, at Reason Two.)

Reread (or consider, if you are reading it for the first time) this assertive paragraph from a widely read and frequently cited critical essay on photography first published in 1973 by Susan Sontag. Sontag (d. 2004) was what is often called a *public intellectual*; her reputation as an authority is as established as her tone is confident and assertive, aphoristic if not oracular. She is writing about the photographer Walker Evans (1903–1975), who was still alive and working as an artist when this essay was published:

> Evans wanted his photographs to be "literate, authoritative, transcendent." The moral universe of the 1930s being no longer ours, these adjectives are barely credible today. Nobody demands that photography be literate. Nobody can imagine how it could be authoritative. Nobody understands how anything, least of all a photograph, could be transcendent.[16]

Somewhere in there, lurking beneath the rhetoric, are some basic principles—presuppositions, actually. These

16. Susan Sontag, "America, Seen through Photographs, Darkly," in *On Photography* (New York: Picador, 1990), 31.

presuppositions have been supposed for so long that the energy and thought that went into their original formulation no longer figure into the thinking of most readers, perhaps not even fully into the thinking of the writer, who confidently takes a number of things for granted. The passive—that is to say, unquestioned, and unwon by the hard work of thinking these things through again—acceptance of these suppositions amounts to a retreat from critical thinking. Perhaps the writer is merely impatient, too eager to rush ahead with her indictment to bother unpacking every single Black Box she relies on along the way. But, as an examination conducted at a less-than-breathless pace discloses, some of these boxes are pretty large.

Sontag's essay is not a dismissive criticism of Evans's intention. She refers to him elsewhere in the essay as a "great" [her word] artist. But she describes him as the *last* great artist to use photography in Whitmanesque celebration of the importance and dignity of humble things. Though Stieglitz and Steichen (earlier Strong Artists) were drawn to "noble" subject matter (moody landscapes, "important" architecture, and heroic portraits), both had occasionally made art photographs of lowly subject matter. Evans extended their range enormously, consistently turning his camera on the tumbledown main streets of small rural towns, and on the faces and houses of the poor.[17]

17. For example, Alfred Stieglitz (1864–1946) made a photograph of a bough of apples seen against the gable of a frame farmhouse in 1922; Edward Steichen (1879–1973) photographed milk bottles on a fire escape in 1917. Evans (1903–1975) explored the obscure and the overlooked from the beginning of his work as a photographer in 1928 until its end in late November or early December 1974. His last photograph was of a discarded fisherman's float.

But during the years since Evans's work in the 1930s, Sontag goes on to say, we have lost faith—and interest—in the optimistic view of the ordinary she finds in Whitman's verse and in Evans's pictures. By 1973, the "moral universe" had changed. These changed circumstances (and the changed art photography appropriate to them, *required* by them) are what the quoted paragraph intends to establish.

In 1973, a photograph is unable to ("nobody can imagine how it could") be *authoritative*, but clearly not because *nothing* can be authoritative anymore: her statement itself is authoritative in the extreme. If not itself *literate* (it lacks the references to literature and to bodies of thinking that might explain the assumptions upon which it depends), her paragraph is certainly *rhetorical*: the triple repetition of *nobody*, each time at the beginning of a simple declarative sentence, hammers her point home not with reasoning, but with force. It may be that the assertive force serves to put on the bravest face, covering over assumptions open to question.[18]

18. The phrase *moral universe* is an interesting one, a term I first encountered in a line spoken by a Woody Allen character who is justifying his dalliance with another character's girl: "The artist creates his own moral universe." (*Bullets over Broadway*, 1988.) *Moral* comes from Latin *mores*: how most people act, acceptable behavior. *Universe* means the One which includes everything, all that is. How can *all that is* be linked to *what most people do*? Which people? *Universe* is totality, all there is, the inevitable; *moral* suggests a choice among alternatives. Can there be more than one universe to choose from?

A Google search turns up a large number of uses of the term *moral universe*, but most of them are of relatively recent date, from the last few decades, during which the term "moral universe" has become a popular phrase, a way to yoke high-minded, enlightened ideas about right behavior

As for *transcendence*, she will have none of it. She said elsewhere that after seeing the photographs made by the Allies of liberated concentration camps, nothing ever was

with the relativistic (and equally enlightened) concept that not all things are the same for all people. Perhaps the term's most prominent recent usage was by Dr. Martin Luther King, Jr., who in several speeches delivered near the end of his life describes the "arc of the moral universe" as long, but bending toward justice.

Interestingly, in the context of King's speeches this notion of arc takes on a temporal meaning, as if the arc were a trajectory, one that aims toward justice as an artillery shell travels toward its target, over time. Just before saying the arc of the moral universe is long, King emphasizes that time is passing, that we are moving ahead. He asks: How long will it take? When will . . . (repeated four times)? How long (repeated five times)? Each time he answers: Not long, and then, after the fifth question/answer, gives this reason: "because the arc of the moral universe is long, but it bends toward justice." After this, the speech concludes with the narrative—enacted over time—of the coming of the Lord of which "mine eyes have seen the glory." The arc of King's universe is not a thing, but rather a *history*. (Speech on the steps of the State Capitol in Birmingham, Alabama, March 25, 1965, text available at <www.mlkonline. net/ourgod.html>.)

In the source for King's reference—a sermon published in Boston in 1852 by Theodore Parker, an abolitionist preacher—the image is spatial rather than temporal: Parker's image stresses the enormous *size* of the moral universe, and not its changes over time:

> I do not pretend to understand the moral universe; the arc is a long one, my eye reaches but little ways; I cannot calculate the curve and complete the figure by the experience of sight; I can divine it by conscience. And from what I see I am sure it bends toward justice. ("Of Justice and the Conscience," in *Ten Sermons of Religion* [Cambridge, Mass.: Metcalf and Company, 1852], 84–85)

The image here is of an observer looking at the whole earth, unable to see the curvature but nonetheless able to understand that the surface is curved: the arc is long, the curve too gradual to see, but a sense higher than sight discloses to the viewer that the surface does in fact curve. It is not a future event but rather the completed figure—the long arc extended over a great

the same for her.[19] The culture that produced transcendental philosophy also produced the camps. Photographs may embody all the lamentable intellectual deficiencies

distance—which must be divined, understood (rather than seen) to be circular in shape. King was not only accomplished but talented as an orator. He adapted his source to serve his immediate political purpose. Description of a *thing* becomes the narrative of an *event*. *Understanding* becomes *action*.

The other nonrecent reference to *moral universe* I was able to find is also spatial rather than temporal. William Ritchie Sorley (in the Gifford Lectures given at the University of Aberdeen in 1914–1915, published by Cambridge University Press in 1918 as *Moral Values and the Idea of God*) compares the moral universe with the physical universe: both are unimaginably large and diverse. As there is an infinity of things in the physical universe, so is there a very large number of individual people faced with different functions and duties, all of which involve moral considerations. The variety of all these possible choices and consequences adds up to an infinitely varied moral universe, one which is "something persistent and permanent, pointing toward a completeness which may deserve the name of absolute" (p. 151). The moral universe, to this thinker, is that steady and constant thing by which we know what is right in all the impossibly large number of circumstances. It is not a constellation of provisional values which change over time.

Even though *universe* means the *all*, everything that is, writers have used the not-in-a-strict-sense-logical but forceful image of *multiple universes* since the time of Milton at least. Carlyle in 1837 supplied one of the best: "To Newton and to Newton's dog Diamond, what a different pair of Universes!" (Cited in the *Oxford English Dictionary*.)

A moral universe unimaginably large, but stable and unchanging? A moral universe changing from moment to moment, like Heraclitus' river? If there are universes, succeeding one another so rapidly that the change is perceivable to mortals, then some things appear and then disappear with finality. If there is one universe, immeasurably large, then all things continue, though the wanderings of any single inhabitant/observer at any particular time may take him away from regions which, though distant, are still (with great effort) recoverable, still perceivable, perhaps even still serviceable.

Which is it, and by what necessity? These are matters that could be "gone into a little further"—a phrase common in the Socratic dialogs—but not in a footnote to an essay on another subject, and certainly not in a dependent clause made to serve as an unquestioned premise.

and all the pernicious psychological excesses her essays describe, but one thing they *don't* embody or participate in is transcendence.

But she is not talking only about photographs. She asserts that "nobody understands how *anything* [emphasis added], least of all a photograph, could be transcendent." It's not just that photographs can't be transcendent; her assertion denies the possibility of the concept. Does the *idea* of transcendence no longer have being in 1973? Does the *moral* universe also include a universe of ideas? *Moral* has to do with what use we make of ideas: a particular age may not make use of the virtue of charity, but to make this assertion is not the same as asserting that the *idea* of charity no longer exists. The transience of consensus behavior and the being of ideas need to be considered separately, but Sontag's sweeping rhetoric ignores the distinction: she takes what is *other* to be *the same*.[20]

19. "And I think I could say that my whole life is divided into before I saw those pictures [of Belsen-Bergen] and after." (Interview with Bill Moyers, NOW, April 3, 2003; printable transcript available at <www.pbs. org/now/transcript/transcript_sontag.html>.)

20. *Moral universe* is a tight, neat package of language that rolls off the tongue and sticks in the memory. A distinction between the manner of being of moral consensus, on the one hand, and the being of ideas, on the other, does not lend itself to a phrase we might encounter in the dialog of a movie written by Woody Allen, or in a speech by Dr. King—and rightly so, since Allen is concerned with snappy entertainment, and King was concerned with speech urging action. But a critical (i.e., close and careful) reader is supposed to be concerned with truth (defined by Kant as a description which corresponds to an actuality).

Sontag's repeated use of *nobody*—especially her third—deserves a little further attention. She cannot mean, literally, *not one single person.* Surely in 1973 a few people still believed in categorial formulations, a god, nonutilitarian values, etc. When she says *nobody*, she clearly means *nobody whose opinion counts for anything.* She is giving voice to the received wisdom of those whose opinions matter, the advanced thinkers: those whose ideas have changed with the times. Those whose thinking has made *progress.*

A belief in progress is a common feature of modern thought. As I have said elsewhere (in my amateur's attempt to discuss our notions of time, history, and progress in a 1,000-word summary of Aristotle, Augustine, Kant, and Hegel not yet deemed publishable), I think this faith may find support in the writings of Hegel, who seems to have believed that history, as it progresses, discloses new possibilities while removing others.[21] Certainly this opinion informs much discussion of art in our time. The history of style assumes that a thing can be done with authenticity at a particular time, but not at some later time, when the horizon of possibilities is different. So while it may have been authentic for Thomas Eakins (as an American painter struggling to establish a specifically American art) to paint the figure in 1875, it was not authentic for Andrew Wyeth to do the same thing in

21. A fuller discussion of our changing ideas of time (and the contribution of G. W. F. Hegel to this history) is beyond the scope of this essay. An abbreviated introduction to this subject is too long to include as a footnote even by my standards.

1975, when so many concerns other than the one that motivated Eakins were more pressing.[22]

Some changes in artistic style result from technical advances. After perspective was developed, for example, European pictures began to look different from how they had looked before. This was a change that was (arguably) necessary (at least for painters whose goal was to represent visual experience), a change to a possibility that had not formerly been technically available. But what caused large numbers of talented and prominent twentieth-century painters working in America to abandon clearly delineated biomorphic form in favor of active brushwork freely applied to large canvases? Was it simply a change in the *Zeitgeist*, and thus in the horizon of "authentic" possibilities available during a particular historical moment with its own particular pressures and concerns? Or did the complex of causes at work include the less necessary kind of change known as *fashion*?

The repeated *nobodys* in Sontag's assertion suggest a fashion of ideas. Fashion rejects the old or familiar not because it no longer has meaning and use, but simply because it is old and familiar. In fact, old things (especially thinkings which originated long ago) sometimes appear

22. "In a world that has Ellsworth Kelly, Jasper Johns and Willem de Kooning you don't give Andrew Wyeth a one man show. To the naïve viewer, his art looks hard to do. It's got a lot of strokes and it would appear to be time-consuming. It is a bit astonishing, but it's a conjuring trick." Henry Geldzahler quoted in Douglas McGill, "'Helga' Show Renews Debate on Andrew Wyeth," *New York Times*, February 3, 1987.

worn out because we no longer consider them carefully. We think we know them well because they've been around for so long. But in fact, we've fallen into the habit of referring to them in shorthand, and in the process we have actually lost, or forgotten, the vital content and potential for relevant meaning these old things may still possess.

Consider a couple of examples, timeworn chestnuts many advanced present-day thinkers might consider to have outlived their usefulness long ago:

Think of Walker Evans's well-known close head-and-shoulders portrait of Allie Mae Burroughs (taken in 1936), a harrowing, terrific thing. But seeing it as that involves the effort needed to cut through its iconic familiarity and all its accreted baggage about rare vintage prints, prices at auction, the ethics of exploitation, the gaze, its recontextualization by appropriation artists, and so on. Someone who has a print at home may be lucky enough to lift a box lid late some night, while trying to find something else, and suddenly see that face staring back, as if for the first time. The brief reverie following an accidental encounter at an unexpected time may be about the only occasion left that allows a viewer to uncover the real content of that famous picture. The picture is powerful still, but it's harder for us to recognize and experience its power without being distracted by its fame, and dulled by its familiarity.

Or think of the dialogs of Plato, a collection of writings most students today encounter in undergraduate survey courses, if at all, or know by reputation as something often

referred to in brief summary. (One of Sontag's essays is titled "In Plato's Cave"; my daughter's ninth-grade history textbook contained a one-page boxed sidebar summarizing "the allegory of the cave.") One might be tempted to say: Nobody reads them anymore. But in these dramatic poems, the conversing about and the acting out of virtues are as carefully balanced as they ever were. They resist summarizing and excerpting as much as they ever did. If anything, these texts are richer than any time since they were written out because of the several generations of perceptive commentary written since knowledge of Ancient Greek fully emerged from its domination by Latinate scholarship. Still, for a secular, pragmatic modern some effort is required. You have to read what the words (and notes) actually say, and not what you expect them to say. You have to be prepared not to close the book when you read about *beautiful* actions, *souls* doing this or that, things that are images of ideas rather than the other way round, or the Good itself as opposed to a good this or that. Encountering these texts requires the reader to work at discovering how words with meanings now hopelessly blurred function in the demanding world of the text before her (accurate notes and thoughtful commentary will help with this work). To paraphrase Faulkner, these texts from the past are never dead. They are not even past.

Nobody calculates a square root using the long-form algorithm. Soon, we may be able to say that *nobody* does long division. Does that mean that all the steps in computation needed to arrive at the result have disappeared? Or only

that these steps are now done out of our sight, by some-
one (or -thing) else? To forget these steps carries risk; to
forget that they ever existed may be disastrous.[23]

*Nobody understands how anything, least of all a photo-
graph, could be transcendent.* Either the craft of picture-
making looks toward a goal higher than pleasing visual
design or simple description, or it doesn't. A higher goal
might be the same as the goal of the dialectic-like process
described earlier: question-and-answer leading farther
and higher, away from the simple and obvious toward the
not-so-simple and not-so-obvious. As long as the ques-
tion-and-answer process holds together, what survives
scrutiny moves closer to an understanding that goes
beyond—*transcends* (from Latin *trans scandere, to climb
across*)—literal description of the things the picture
shows, the list of things in a screen shot of a Google Earth
view. Is this something *nobody understands*, or something
*no sophisticated citizen of the present-day world would
choose to believe?*

Whitmanesque optimism is not a literate or transcen-
dent idea residing in the handmade chairs, roadside signs,
and hardware store displays Evans photographed. It is
rather something understood by the "reader" of the pic-
tures, a something that comes not so much as a result of

23. For a detailed account of the steps in thinking needed to pass from
the understanding of *number* as a collection of discrete things to what we
refer to (in shorthand) as *square root*, see Harvey Flaumenhaft, "Why We
Won't Let You Speak of the Square Root of Two," *St. John's Review* 48,
no. 1 (2004): 7–41.

looking at a single view as from looking at (and then generalizing about) an ordered collection, the kind of presentation a viewer encounters in a gallery exhibition, or in a picture book. The strongest, most concentrated book produced by Evans is *American Photographs*. Those of you who know that book well will also know it delivers to its reader/viewer no single overriding message, neither Whitmanesque optimism, nor "what people from the left tier think America is" (Ansel Adam's reading),[24] nor anything else. Its strategy is to counterpoise contraries, from picture to picture in the sequence (pictures are presented one to a page, each opposite a blank page so the reader encounters a sequence of single pictures, not a "layout" combination of several), and sometimes to counterpoise contraries within the borders of a single picture. The strategy actually *subverts* settled meaning; this strategy was likely conceived (at least in part) *in recoil* from the technique used by the picture editors of *Life* magazine, who liked picture-sequences to tell a simple story (and provided helpful captions to aid anyone who might not immediately get the point). It was likely conceived (in part) *in recoil* from the easy, glib opinionating Evans so detested.[25]

24. Ansel Adams, letter to Edward Weston, 1938, quoted in James Mellow, *Walker Evans* (New York: Basic Books, 1999), 381.

25. This assessment of Evans's skeptical temperament is based on my several years' experience of his informal personal conversation. But at least one preserved written document lends support. Here is Evans writing to the Ford Foundation in a letter dated April 29, 1960. He was then in his

The more you look at pictures by Evans and the more you know about his work and life, the more difficult it is to speak with confidence about what his pictures "mean," or about what his "vision" is. Evans as an artist calls our attention to humble objects, out-of-the-way places, and details of gesture, attitude, and character we would not likely have seen so clearly without his agency. Like another great mimetic artist—William Shakespeare—Evans brings these things to our attention. He doesn't tell us what to think about them.

In considering Evans, we might do well to adopt the approach Henry Adams took to the work of another American artist, Augustus Saint-Gaudens. Here is Adams (writing in the third person) on his visits (in 1892) to the bronze memorial figure he commissioned from Saint-Gaudens for the grave of his wife Marion:

> Naturally every detail interested him [Adams]; every line; every touch of the artist . . . as the spring approached, he was apt to stop there often to see what the figure had to tell him that was new; but, in

fifty-seventh year, had for fourteen years been a regular employee of *Fortune* magazine, and would soon be invited to join the Century Association in New York City. The settled attitude this excerpt suggests can hardly be dismissed as the temporary one of an angry young man:

[My] work is in the field of non-scholarly, non-pedantic sociology. It is a visual study of American civilization of a sort never undertaken at all extensively by photographers, who are all either commercial, journalistic, or "artistic." . . . [My book] may call attention to the seriousness in certain small things; it may reveal the emptiness of certain big things.

all that it had to say, he never once thought of questioning what it meant. . . . The interest of the figure was not in its meaning, but in the response of the observer. As Adams sat there, numbers of people came, for the figure seemed to have become a tourist fashion, and all wanted to know its meaning. Most took it for a portrait-statue, and the remnant were vacant-minded in the absence of a personal guide. . . . The only exceptions were the clergy, who taught a lesson even deeper. One after another brought companions there, and, apparently fascinated by their own reflection, broke out passionately against the expression they felt in the figure of despair, of atheism, of denial. Like the others, the priest saw only what he brought. Like all great artists, St. Gaudens held up the mirror and no more.[26]

The time-bound message Sontag complains of is in fact her own reading—part of her own *passionate reflection*—and not any content embedded in the pictures themselves, or in the things they show, or in the arrangement of these things. Sontag has confused the pictures with her own understanding of them, taking for *the same* two things which are in fact *other*. She has projected her own radical contemporaneity—her firm solidarity with those in the present-day know who stand against the *nobodys*—onto the ideal constructions she takes to be slaves of fashion.

26. Henry Adams, *The Education of Henry Adams* (Boston: Houghton Mifflin, 1964), 329.

Sontag's way of understanding photography in general (and Evans in particular) is dashing, aphoristic, brilliant. Her style of discourse may open a window to the clear air of genius, but—caught up as it is in her own passionate reflection—it closes the door leading to the pathetic understanding of an *other*, the very task photography is uniquely fitted to mediate. This way, this style, closes the door to understanding a *topic* in discourse as surely as the too-narrow projective vision of what I have called a *studio artist* can, in her work, close off the possibility of understanding *what is.*

Nitpicking and footnotes are not to everyone's taste, at the present time. But sometimes, when there is a lot to say, it is better to say it, or at least direct the reader to where it is discussed in greater detail, than it is to elide and rush on to the conclusion. Conclusions drawn from elided evidence may have more in common with a large castle of carefully balanced playing cards than with a modest (but well-constructed) cube or prism.

Essays written to the modernist taste—unfootnoted, brief, crisp, aphoristic, tendentious—make up a large part of present-day discourse on photography. Taken together, these dozens, by now hundreds of efforts make up our present-day attempt to *understand* photography: what it is, what it can do, its importance. A student new to the field may feel a little like a hiker who encounters the kind of thicket of underbrush that springs up when once-cleared farmland goes out of cultivation. What such a walker encounters is a profusion of thin, long branches

from different plants, intertwined and reaching in every direction. Some have thorns and some not; trying to pull the individual branches apart is a messy, tiresome, even painful business. Long effort results in little progress.

If the walker has a long brush hook, she may be able to clear away some of the tangle nearest the ground. If so, she will discover that all the tangled branches stem from a finite—large perhaps, but finite—number of trunks emerging from the ground. If you can somehow encounter the bushes nearest the ground, you can deal with the plants one at a time and perhaps make a little progress.

Present-day discussion (of photography, of almost any subject) tends to take place up in the canopy, so to speak: the reader jumps from branch end to branch end, from leaf to single leaf, from bud to cone. We are too far from the roots to get a sense of structure. Where do all these buds and leaves come from? What is the overall shape?

The point of this comparison is not to imply that present-day discussion of photography is worthless and troublesome, as some might think overgrown farmland to be. Far from it. A protean medium, photography connects to and insinuates itself into other disciplines, other modes of thinking, and invites analyses from multiple points of view.

But discussions that begin with, say, the ethics of exploitation or the relationship of the viewer to the art object lead us in various directions—directions that distract us from considering what photography, in and of itself, actually is, apart from the various applications it lends itself to. If there was ever a unitary way of thinking

about photography—as a reporter of the condition of the world—that unity has long since vanished.

The forest of discourse has gotten very large since the time of John Donne. Eliot liked to say that Donne's was a time when all branches of knowledge could come into intimate contact in a single sensibility.[27] Today we know mostly pieces of things. Many of us have conversations about ideas (as opposed to our conversations about projects at work, or about the logistics of real estate, schools, travel, planning, etc., which go on incessantly). But serious discourse for most of us is largely passive: we spend a lot of time listening to or reading micro-experts, specialists who sometimes talk beyond the range of their expertise. We construct a worldview by connecting the dots, by drawing intellectual lines among the personalities we "follow"—in conversation, at conferences, in books and periodicals, on television, on line, on Twitter, or in museums and galleries, if visual art matters to us. Some among us take in more in a day than all but the most active and privileged devotees of culture in the eighteenth century might see in a year, or a lifetime. We are driven to summary, to brevity, to concision and other short cuts to make sense of—to "process"—all we see. We rely constantly on Black Boxes, and we rarely have the time or leisure to unpack them.

27. See T. S. Eliot, "The Metaphysical Poets," in *The Norton Anthology of English Literature* (New York: W. W. Norton, 1962), vol. 2, 1508–1516. This review of Herbert Grierson's anthology was first published in 1921 but has been frequently reprinted.

A commuter will leave his home in the northern sub-
urbs of New York City at 6:30 or 7 a.m. to drive on a
six-lane highway at 70 or 75 miles an hour in a car sepa-
rated from the ones in front, behind, and on either side
by only a few feet, often talking on the phone while he
drives. He works a full day in an office or cubicle where
he gives his attention to three or four electronic devices,
an attention interrupted only by the meetings he will
attend during the workday (when he will monitor only
one or two devices, in addition to participating in the
meeting). At home he will attend to family matters and
perhaps read some, or watch more media to keep up on
news not available at the office or in the car. For many
Americans who have managed to succeed in getting
something of what they want, this is present-day life.
Eliot considered present-day life at the time of his essay
(1921) fractured because during the course of a single day
a man might listen to a typewriter, make love, cook an
egg, read Spinoza. Except for listening to the typewriter,
our present-day commuter might do all this (and still
have time for his run or workout) before breakfast.

 Photography is a present-day art, one that arose as the
fragmented urban/office life familiar to Eliot was coming
into being. Photography was embraced as an ultimate
short cut: it yielded automatic pictures, more accurate
than hand-drawn ones, able to be made without spending
time on either lengthy training or laborious execution.
And soon, the camera became the ultimate (and literal)
Black Box: as George Eastman's advertising said (in

1888): You press the button and we'll do the rest! The photographer exposed all the film the camera came with, sent the camera box in to Kodak, and got back his pictures along with the same black box, reloaded with fresh film.

But this particular short cut contained the germ of something richer, as Talbot's observation acknowledged, an aspect of its operation that opened a door back to ancient epistemology. The subjective self—the *I* who is necessary to understand the world—rose to prominence relatively recently, during the stretches of the European past we call Renaissance and Enlightenment, when widespread individualism became not only possible but also attractive. ("People became persons in fifteenth-century Italy," in critic Peter Schjeldahl's succinct formulation.)[28] Earlier understanding had been dominated by the systematic thinking of Aristotle, in which the ordered cosmos holds pride of place; man's job is to understand that structure (as far as possible) and to live in harmony with it. Every thinker in the Western tradition recognizes some kind of balance between what happens *inside*, in the individual man or woman, and, on the outside, *what is*. But in antiquity, thinkers paid more attention to *what is*. Recent thinkers are more likely to start *within*, to lean toward the proposition that *man is the measure of all things*.[29]

28. Peter Schjeldahl, "Persons of Interest," *New Yorker*, January 9, 2012, 14.

29. Not a new notion. See Plato, *Theaetetus*, for Socrates' enactment (and refutation) of an argument by Protagoras (ca. 490–420 BCE) that *man is the measure of all things*.

A man (or woman) with a camera may be the measure of all the things she understands to be worthy of her attention at the moment she frames her picture, but she is not the measure of *all* things. There is Talbot's dial-plate to consider, for one thing, and (for another) the kind of reading any later viewer may come up with of the intractably real things the pictures show (think of Sontag's reading of Evans, or my reading of any of the photographs I have discussed). The photographer cannot be the ultimate measure of *that*.

So the *short cut* of photography also leaves a door ajar, one leading in the direction of *things as they are*, a notion that might have made more sense, and have been more appealing, to Aristotle than to Descartes. And the *Black Box* of optics and chemistry turned out to be an advantage in this regard: the less the involvement of the operator's trained eye and trained hand, the less dominance that operator's learned pictorial expectations will exert over the final picture. Pictures by even the greatest photographers (Coomaraswamy's claim for Stieglitz notwithstanding) insist on containing elements of the outside world that just happened to be there.

Most art photographers we have heard of are, in some measure, personalities. A reputation today depends upon having something like a signature style. An artist must have some kind of identity before the viewing (and buying) public can link her name to a body of work: before she can become a brand. This state of affairs is how things work, today. It is our time. You might say

these things compose our present-day *moral universe*, if you will (though perhaps you won't, if you are a reader of footnotes).

The market has the potential to enable geniuses—to identify overarching talents and reward them with the means to do huge things, things which, without the money supplied by collectors, museums, and foundations, would not be possible. But photography, as I have been understanding it in this essay—and I have been understanding it as a medium whose business is to understand some aspect of the world humans live in, a medium whose epistemological potential makes it unique among the picture-making arts, a medium more properly concerned with describing in the toughest, deepest, most penetrating way than with constructing fantasies pleasing to the eye or imagination—photography as I have been understanding it is a small-scale business, a cottage industry. Its main requirements are dedication and huge amounts of time. The tools and materials needed are not extravagant. Talent helps, but (as I have argued) conspicuous talent may be an obstacle. I have also suggested that fame and its rewards are distractions.

It may be that the largesse provided by the market and its allies has made possible work of genius in photography. Numerous curators and critics view the changes in art photography since its embrace by the high-priced art market as a great leap forward, the long-hoped-for emergence of a group of talented artists from what more observers than one have called the "ghetto" of photography. The large,

made-for-the-wall pictures these talented artists are pro-
ducing will likely have a prominent place in art history,
but I think that place will be in the company of the large
paintings to which so many of them refer rather than in
the ghetto of photography. If a prominent museum ever
again hangs its picture collection in the form of a chrono-
logical narrative, these large (in the 10-by-8-foot range)
pictures produced by photographic means will probably
claim a place somewhere after Pop.

It may be that this money-fueled expansion has
brought forth works of genius, but these large, color,
meant-for-the-wall (and not just any wall) works inhabit
a world of ambitions and achievements I can't think of as
photographic, in the sense I have been using that word in
this essay. I would call such works products of *studio art*.
All the achievements in photography I admire most are
smaller, and quieter. Most have come from workers on
small budgets who (at the time they made the work I
admire most) had as yet little support from the market,
and some little recognition from any quarter. All the pho-
tographs I admire engage the viewer/reader the way a
page of text does, rather than overwhelm her with huge,
spectacular presence. All are the result of a lot of walking
and looking.

The market's recent (since about 1975) embrace of pho-
tography may yet yield great things. Leslie Katz (d. 1997), a
writer and publisher with a deep knowledge of the making
and appreciation of art in the mid-twentieth century, took
the view that the greatest talents are incorruptible; one of

his favorite examples was a photographer, Walker Evans. (Another favorite example was Louis Armstrong.) Maybe he was right.

Photographs are made by personalities. But any person (recall: Latin, *per sonare*) is only a medium, a messenger. *What sounds through*—what shows through—is the message. The message is *what is.* The number on the distant dial-plate is the irrelevant detail that changes the story, the party-crasher who makes the party memorable. Photography understands this, even if photographers don't. That is why photography matters.

Amenia, New York, February 14, 2012

Bibliography

Adams, Henry. *The Education of Henry Adams*. Boston: Houghton Mifflin, 1964.

Agee, James, and Walker Evans. *Let Us Now Praise Famous Men*. Boston: Houghton Mifflin, 1960.

Aristotle. *Aristotle's Metaphysics*. Trans. Joe Sachs. Santa Fe, N.M.: Green Lion Press, 1999.

Aristotle. *Aristotle's On the Soul*. Trans. Joe Sachs. Santa Fe, N.M.: Green Lion Press, 2001.

Aristotle. *Nicomachean Ethics*. Trans. Joe Sachs. Newburyport, Mass.: Focus Publishing, 2002.

Auerbach, Erich. *Mimesis: The Representation of Reality in Western Literature*. Trans. Willard Trask. Garden City, N.Y.: Doubleday, 1957.

Bely, Andrei. *St. Petersburg*. Trans. John Cournos. New York: Grove Press, 1989.

Bloom, Harold. *The Anxiety of Influence*. Oxford: Oxford University Press, 1973.

Brann, Eva. *The Music of the Republic*. Philadelphia: Paul Dry Books, 2004.

Bry, Doris. *Alfred Stieglitz: Photographer*. Boston: Museum of Fine Arts, 1965.

Cartier-Bresson, Henri. *The Decisive Moment*. New York: Simon and Schuster, 1952.

Cartier-Bresson, Henri. *Photoportraits*. New York: Thames and Hudson, 1985.

Chernyshevsky, Nikolai. *What Is to Be Done?* Trans. Michael Katz. Ithaca: Cornell University Press, 1989.

Crawford, William. *The Keepers of the Light*. Dobbs Ferry, N.Y.: Morgan and Morgan, 1979.

Due, Marcia. "Marcia Lea Due, Photographs, 1978–1989." Introduction by Leslie George Katz. *New Renaissance* 8, no. 3 (Spring 1993): 104–112.

Due, Marcia. *Photographs*. Hastings-on-Hudson, N.Y.: Newington-Cropsey Foundation, 2008.

Eliot, T. S. "The Metaphysical Poets." In *The Norton Anthology of English Literature*, ed. M. H. Abrams et al., vol. 2, 1508–1516. New York: W. W. Norton, 1962.

Evans, Walker. *American Photographs*. New York: Museum of Modern Art, 1938.

Evans, Walker. "The Reappearance of Photography." *Hound and Horn* 5, no. 1 (October–December 1931): 125–128.

Evans, Walker, Estate of. *Walker Evans at Work*. New York: Harper and Row, 1982.

Frank, Robert. *The Americans*. New York: Grossman, 1969.

Friedlander, Lee. *Lee Friedlander Photographs*. New City: Haywire Press, 1978.

Frye, Northrop. *Anatomy of Criticism*. New York: Atheneum, 1966.

Groover, Jan, and Michael Collins Groover. *Jan Groover: Kitchen Still Lifes 1978–1979*. New York: Janet Borden, 2006.

Heidegger, Martin. *Early Greek Thinking*. Trans. David Farrell Krell and Frank A. Capuzzi. New York: Harper and Row, 1984.

Heidegger, Martin. *Parmenides*. Trans. Andre Schuwer and Richard Rojcewicz. Bloomington: Indiana University Press, 1998.

Heidegger, Martin. *What Is a Thing?* Trans. W. B. Barton, Jr., and Vera Deutsch. Chicago: Henry Regnery, 1967.

Kant, Immanuel. "Critique of Aesthetic Judgement." Trans. James Creed Meredith. In *The Critique of Judgement*, 476–549. Chicago: Encyclopaedia Britannica, 1952.

Katz, Leslie George. *Message from the Interior*. New York: Eakins Press Foundation, 1993.

Keats, John. *The Complete Poems*. Ed. John Barnard. London: Penguin Classics, 1977.

Kirstein, Lincoln. "Photographs of America: Walker Evans." In *American Photographs*, 187–195. New York: Museum of Modern Art, 1938.

Kirstein, Lincoln. *Quarry: A Collection in Lieu of Memoirs.* Santa Fe, N.M.: Twelvetrees Press, 1986.

Klein, Jacob. "Aristotle (1)." Ed. Burt C. Hopkins. *New Yearbook for Phenomenology and Phenomenological Philosophy* 3 (2003): 1–19.

Klein, Jacob. *A Commentary on Plato's Meno.* Chicago: University of Chicago Press, 1989.

Klein, Jacob. *Greek Mathematical Thought and the Origin of Algebra.* Trans. Eva Brann. Cambridge, Mass.: MIT Press, 1968.

Papageorge, Tod. *Core Curriculum.* New York: Aperture Foundation, 2011.

Plato. "Phaedo." In *The Dialogues of Plato*, trans. Benjamin Jowett, 220–251. Chicago: Encyclopaedia Britannica, 1952.

Plato. *Plato's Sophist or the Professor of Wisdom.* Trans. Eva Brann, Peter Kalkavage, and Eric Salem. Newburyport, Mass.: Focus Philosophical Library, 1996.

Plato. *Plato's Theaetetus.* Trans. Joe Sachs. Newburyport, Mass.: Focus Philosophical Library, 2004.

Plato. *Republic.* Trans. Joe Sachs. Newburyport, Mass.: Focus Philosophical Library, 2006.

Pynchon, Thomas. *Gravity's Rainbow.* New York: Viking, 1973.

Sontag, Susan. *On Photography.* New York: Picador, 1990.

Stendhal (Marie-Henri Beyle). *The Private Diaries of Stendhal.* Trans. and ed. Robert Sage. Garden City, N.Y.: Doubleday, 1954.

Swift, Jonathan. *A Tale of a Tub.* London: John Nutt, 1710.

Szarkowski, John. *Walker Evans.* New York: Museum of Modern Art, 1971.

Szarkowski, John. *Winogrand: Figments from the Real World.* New York: Museum of Modern Art, 2003.

Szarkowski, John, and Maria Morris Hambourg. *The Work of Atget.* 4 vols. New York: Museum of Modern Art, 1981–1985.

Talbot, William Henry Fox. *The Pencil of Nature.* New York: Da Capo Press, 1969.

Thompson, Jerry L. *The Last Years of Walker Evans.* London: Thames and Hudson, 1997.

Thompson, Jerry L. *Truth and Photography.* Chicago: Ivan R. Dee, 2003.

Trachtenberg, Alan. *Reading American Photographs.* New York: Hill and Wang, 1989.

Winogrand, Garry. *The Animals.* New York: Museum of Modern Art, 1969.